J.M.W. Turner

Christopher Wynne

Wisdom with
Understanding
is Better
Than Rubies

Lurine Karon
Fine Arts Coll

D1531229

Prestel

Munich · Berlin · London · New York

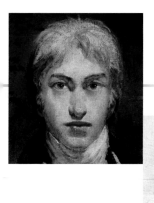

Inspiration from England

Light and colour are synonymous with the work of the British painter
and printmaker Joseph Mallord William Turner. An extraordinarily
prolific artist, he dominated British landscape painting throughout
the first half of the nineteenth century and established an unequalled
reputation, initially on account of his topographical studies and later
as a painter of Sublime and historical landscapes. His paintings often
caused a sensation when first exhibited at the Royal Academy in Lon-
don and a number of his later works were never fully understood by
many of his contemporaries. This, however, did not hinder Turner's
immense success. He devoted his life entirely to painting and travelled
tirelessly, sketching everything he saw. When he died, his estate
included well over 300 oil paintings and hundreds of finished water-
colours, in addition to the 20,000 sketches and watercolours in the
Turner Bequest.

Family life _ Turner was born on 23 April 1775, in Maiden Lane,
Covent Garden, London. He was called William after his father and
this was the name used by his family. William Turner the elder came
from a Devon family and worked as a barber and wig-maker. He recog-
nised his son's exceptional gift as an artist and his obvious intelligence
at an early age and – unlike the parents of many artists – proudly
announced that his son was "going to be a painter." Turner's father
used to display the young boy's early watercolours and drawings in
his shop window – and these always found ready buyers.

The bond between father and son was unusually strong and Turner
remained devoted to his father all his life. The relationship to his
mother, Mary, however, was difficult. She suffered from a mental

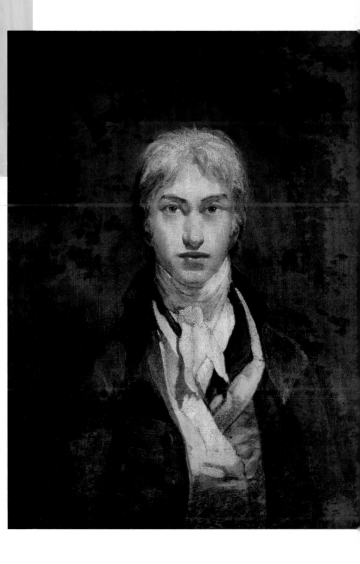

Confidently looking to the future

Portrait of the Artist aged about twenty-three (*c.* 1798), oil on canvas, 74.3 × 58.5 cm,
Tate Britain, London

A View of the Archbishop's Palace, Lambeth (1790), watercolour, 26.5 × 38 cm, Indianapolis Museum of Art

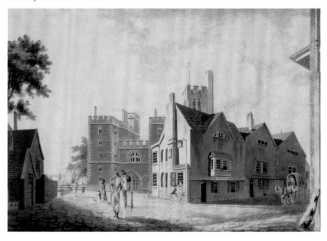

disorder that worsened steadily and, by 1800, she had to be committed to the Royal Bethlehem Hospital, where it would seem she remained until her death four years later.

Early impressions _ Located close to the Strand, the Turner family home was just a few minutes walk from the Thames, the most important thoroughfare in eighteenth-century London. Smoke-filled skies and the mist rising above the river would have been familiar sights to Turner. The majestic view of St Paul's dome over the rooftops, the Houses of Parliament a little further upriver and the spectacle of rigged ships moving up and down the Thames made a strong impression on the young boy. In the other direction was Covent Garden, with all the colours and fascination of any major market. These sights, seen at different times of night and day, haunted Turner all his life and led to his constant experimentation with the effects of light. He was seldom concerned with depicting the individual leaves on a tree, or with including flowers as details in his paintings. Instead, the themes to which he would return time and again were the typically urban phenomena that influenced him most as a child – ships on the river, the moods of the water and, in particular, the play of light seen through smoke or fog.

Moving away from London _ When Turner was about ten, his mother's deteriorating mental health, combined with the illness and premature death of his younger sister, led to his father's decision to send William away from London. The young Turner went to stay with a maternal uncle in Brentford, Middlesex, and later with other relations of his mother's in Margate, Kent. In both these places he produced a number of sketches and it was there that the earliest signed drawings, dated 1786, were made.

Turner's first exhibited work _ On 11 December 1789, aged just fourteen, Turner entered the Royal Academy Schools after a term's probation. It must have been at this time, too, that he started working for the architect Thomas Hardwick and for the architectural draughtsman and watercolourist Thomas Malton, where he gained invaluable experience. This is evident in the first work Turner exhibited – a watercolour of an architectural subject – the *Archbishop's Palace, Lambeth* (1790). Other works of this time include renderings of ruins and picturesque views.

In 1791 he worked briefly as an assistant scene painter at the Pantheon opera house in Oxford Street. When the building was gutted by fire in January 1792, Turner painted a watercolour to record the scene and submitted it to the Academy that spring.

Architectural accuracy with a journalistic touch

The Pantheon, the Morning after the Fire (1792), watercolour, 39.5 × 51.5 cm, The British Museum

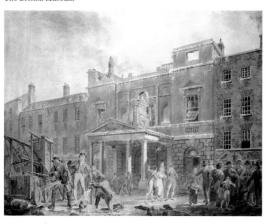

Tours and engravings _ In the early 1790s Turner set out on the first of many extensive tours. He visited the area around Bristol and Bath, before venturing further afield to Wales in the summer of 1792. By now he had started to work in oil – the first extant painting in this medium being a small oval study of a water mill from 1792–93. It was, however, to be his watercolours that would attract the most attention over the next few years, as well as his drawings, for which he was awarded the 'Greater Silver Pallet' by the Society of Arts in 1793.

The first engravings made from Turner's drawings were soon to be published and a trip to the Midlands gave him the necessary inspiration for further series. He also began working on other subjects apart from landscapes, finding much inspiration from literary sources.

Expanding horizons _ In the evenings Turner was employed by Dr. Thomas Monro, Physician to the King and an amateur artist, copying paintings in Monro's extensive collection by such influential artists as John Robert Cozens (1752–99). Turner continued doing this for some three years, deepening his appreciation of the subtleties to be found in the paintings of major topographical artists. He worked together with Thomas Girtin (1775–1802), who became his friend and rival. Together, the two of them would turn landscape painting into an accepted art form. Throughout his life, Turner considered himself as following on directly from the seventeenth-century Classicists Poussin and – more

The romantic Wye Valley also attracted William Wordsworth

The Interior of Tintern Abbey, Monmouthshire (1794), watercolour, 32.1 × 25.1 cm,
The Victoria and Albert Museum, London

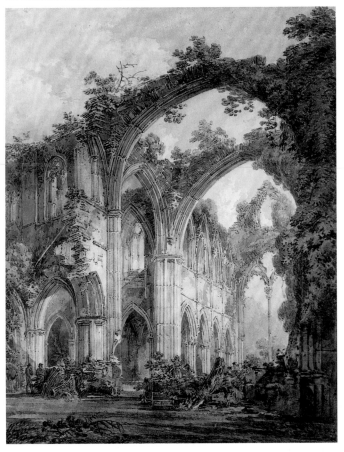

importantly – Claude Lorrain, and he always strove to equal or even surpass their landscape paintings.

Turner never tired of travel. Throughout his life he made extensive tours of Great Britain and, later, of Continental Europe. In 1795 he visited South Wales in the early summer, followed by a trip to the Isle of Wight. Such tours quenched his thirst to experience the countryside and the sea first hand, while enabling him to complete commissions for

private patrons. During such tours he made numerous topographical drawings and was always on the lookout for new motifs for future engravings.

Experiments in oil _ The following year saw the first oil painting by Turner to be exhibited at the Royal Academy. Entitled *Fishermen at Sea (The Cholmeley Sea Piece)*, this work shows no traces whatsoever of the artist's relative unfamiliarity with this medium. Depicting a scene off the Isle of Wight, it is Turner's interpretation of the dangers of the sea and the power of nature. He includes a subtle range of light and shade, from the moon covered by a thin veil of cloud to the reflection from the fishermen's lantern. Such motifs are to recur frequently in other works, such as *Calais Pier, with French Poissards preparing for Sea: An English Packet arriving* (see p. 17 ff).

Patrons and commissions _ Turner's experiments in oil stimulated further developments in his own watercolour technique. He included stunning atmospheric effects in a number of architectural interiors,

A life-long fascination for the sea and for the effects of light

Fishermen at Sea (The Cholmeley Sea Piece) (exhib. 1796), oil on canvas, 91.4 × 122.2 cm, Tate Britain, London

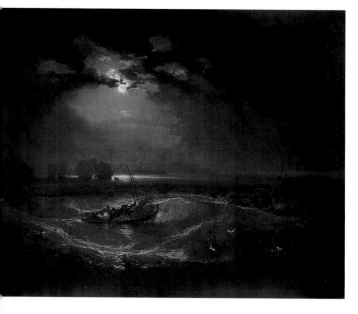

A magnificent building in a romantic frame

South View from the Cloisters, Salisbury Cathedral (*c.* 1802), watercolour, 68 × 49.6 cm,
The Victoria and Albert Museum, London

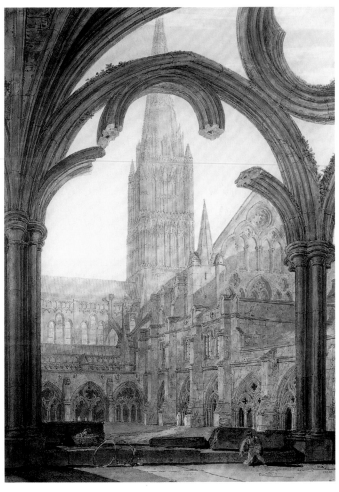

probably having been influenced by Rembrandt and Piranesi, whose
works he had been able to study at the home of an important patron,
Sir Richard Colt Hoare. Two watercolours of Salisbury Cathedral that
he completed at this time were exhibited in 1797 – the first of nearly
thirty works commissioned by Hoare between 1797 and 1805.

The Lord sent thunder and hail and fire ran along the ground"

The Fifth Plague of Egypt (exhib. 1800), oil on canvas, 124 × 183 cm, Indianapolis Museum of Art, Indiana

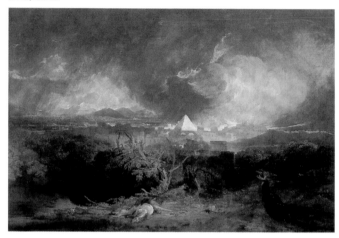

Other patrons of Turner's at this time included the Earl of Essex and the Earl of Harewood. Turner exhibited a number of topographical works at the Royal Academy carried out for these patrons and, as a result, attracted many other commissions throughout the 1790s. This enabled him to continue travelling the length and breadth of the country and included a visit to the north of England and the Lake District in the summer of 1797.

Landscape Painting _ The Romantic spirit of the late eighteenth century changed the general attitude to landscape painting. It had always been regarded as a minor branch of art and the painters who earned their living painting views of country houses, parks or picturesque scenery were not taken seriously. The seventeenth-century French artists Nicolas Poussin and Claude Lorrain, the first to devote himself entirely to landscape painting, as well as the Dutch masters Rembrandt van Rijn and Jacob van Ruisdael greatly influenced the development of this genre.

A strategically positioned stronghold controlling the mountain pass

Dolbadarn Castle, North Wales (exhib. 1800), oil on canvas, 119.5 × 90 cm,
The Royal Academy of Arts, London

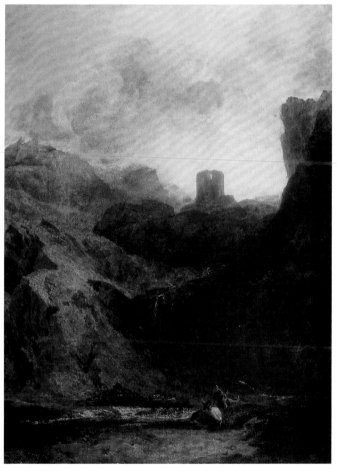

In the late 1790s, Turner completed a number of dramatic sea-
scapes and executed works for patrons such as George Wyndham, the
Earl of Egremont, who was to take a prominent place among Turner's
benefactors. At this time, he also embarked on a succession of large-
scale works in oil and watercolour, many of which were based on paint-
ings by Old Masters. With growing self-confidence, Turner moved into

the field of historical painting and the depiction of Biblical scenes. *The Fifth Plague of Egypt* – actually illustrating the seventh – was the first oil painting in this style to be exhibited (see p. 12).

Turner's popularity and fame continued to grow and, in April 1799, he was recommended to Lord Elgin and asked to make topographical drawings of Athens. This project never materialised, however, as the two could not agree on a suitable salary. Turner remained in England and, on 4 November 1799, he was elected an Associate of the Royal Academy, becoming a full member three years later. The painting he submitted as his diploma piece was a view of *Dolbadarn Castle, North Wales* (see p. 13), reflecting his increasing fascination for dramatic landscapes and especially for Snowdonia. While depicting the sublime mountainous scenery, the historical associations evoked by this stronghold are also essential to its meaning. In a number of watercolours of Welsh subjects Turner proved how this medium, too, could be used for 'serious' purposes.

The artist in private _ In a quest for greater independence, Turner rented and then purchased a house in Harley Street, London, in late

The romance of Snowdonia

Llanberis (*c.* 1799), watercolour, 55.3 × 77.2 cm, Tate Britain, London

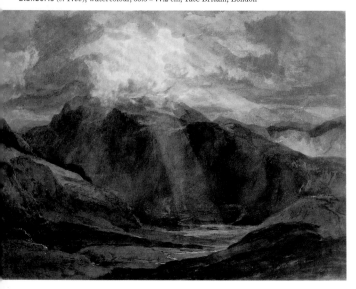

Invoking the spirit of Claude

The Festival upon the Opening of the Vintage at Macon (exhib. 1803), oil on canvas, 146 × 237.5 cm, Sheffield Art and Museums Collections

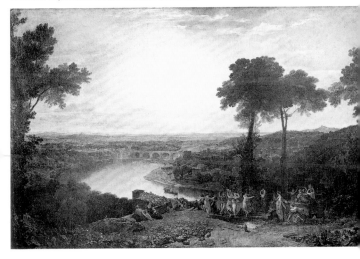

1799. This may, however, have equally well been a convenient move to enable him to maintain a relationship that had recently begun to blossom. Some contemporary sources state that Turner's liaison was with the composer John Danby's widow, Sarah. However, it would seem that it was Danby's niece, Hannah, who was the focus of attention, as Turner arranged for Hannah to live in a house nearby and it was with her that he had two illegitimate daughters, Evelina and Georgina.

Turner's private life always took second place to his painting. He remained fiercely independent and continued to make extended visits on his own to patrons and to the Continent even as an elderly man.

Abroad at last _ A temporary break in the war between France and England in 1802 enabled Turner to make his first tour abroad, travelling to France and Switzerland from July to October. In Paris he studied the paintings in the Louvre, later submitting canvases to the Royal Academy with his 'reply' to works by artists such as Claude (*Festival upon the Opening of the Vintage in Mâcon*) and to Titian's religious subjects. These trips to the Continent were to widen Turner's horizons and enrich his art in the decades to come.

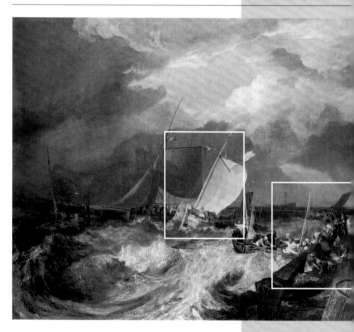

Calais Pier, with French Poissards preparing for Sea:
an English Packet arriving (exhib. 1803), oil on canvas,
172 × 242 cm, The National Gallery, London

French Poissards preparing for Sea

The composition of a dramatic seascape _ A personal experience and other influences

Turner's maritime paintings frequently focus on the unbridled forces of nature, with rolling seas and dramatic skies. *Calais Pier with French Poissards preparing for Sea: an English Packet arriving* is no exception. Exhibited in 1803, it picks up on the theme depicted in *Fishermen at Sea*, adding the artist's own very personal experience of crossing the Channel in 1802. He made several sketches of the rough sea and the storm-swept harbour as he arrived in Calais for the first time.

The majority of sketches that he later used as a basis for his oil paintings are in black-and-white chalks or pen and brown ink with wash on a tinted background. In what is now known as the 'Calais Pier' sketchbook, there is only one study directly related to this painting – drawn on blue paper – depicting the boat with the light-coloured sail in the centre. There are, however, a number of related drawings such as one entitled *Landing at Calais. Nearly swamped*. Turner combined sketches from other journeys with his own memories to create a painting full of movement and tension.

While capturing the everyday difficulties of boats approaching the pier, this painting is also an accurate depiction of a near accident between an English packet-boat and a French fishing-smack. Turner successfully elevates a genre scene, giving it the same status as the Biblical Plagues.

The composition is divided into two clear, horizontal halves. The light shining through the storm clouds is reflected on the crests of the breaking waves in the centre of the painting. The wooden pier on the right draws our eye into the composition while the darker area on the left intensifies the drama of the scene giving it a well-defined frame.

A visit to the Louvre in Paris had given Turner the opportunity of seeing the works of a number of major international artists for himself. *Calais Pier* may be seen as Turner's 'reply' to Jacob van Ruisdael's painting *Tempest* which he had outlined in his 'Studies in the Louvre' sketchbook. Turner was open to the influence of other artists, but his exceptional memory and understanding of natural phenomena enabled him to develop a theme in a number of different ways.

While one newspaper journalist commented on how "the sea looks like soap and chalk," another critic visiting the exhibition described *Calais Pier* as having "many great excellencies, and some defects. The former will be found in the vessel which is moving off, in the grouping, action and character of the numerous figures which are scattered over the pier and on the decks ... But the clouds are certainly too material and opake [sic]; they have all the body and consistence of terrestrial objects, more than fleeting vapours of unsubstantial air."

Turner's exploration of the nuances of diffuse light is reminiscent of painters such as Joseph Wright of Derby (1734–97). The source of light in this painting is the moon, which is shown frontally – a common

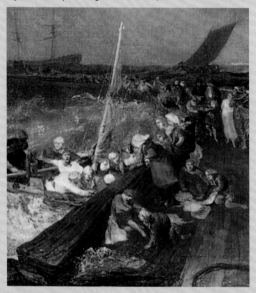

phenomenon in many of Turner's paintings in which the viewer looks directly at the sun or moon.

The title Turner gave this painting is typically haphazard. The pseudo-French word 'Poissards' cited in the Royal Academy catalogue in 1803, seems to have been made up by Turner, taken from the French *poissarde* – a fish-wife.

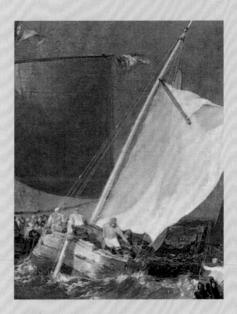

Calais Pier extended the range of Turner's ambitious seascapes and led to the painting *The Shipwreck*. Exhibited in 1805, the drama of this work is intense, highlighted by the whipped-up waves and the threatening sky which focus the attention of the viewer on the lower section of the painting. The light breaking through the clouds on the horizon falls on the shipwrecked passengers while the sail, catching the light on the right, draws the eye upwards to the crest of the waves and across to the boat on the left. The viewer is automatically drawn into the swirling mass in a more dramatic and powerful manner than in *Calais Pier*.

Both works, however, underline Turner's gift for capturing the force of nature and his mastery in handling light and colour.

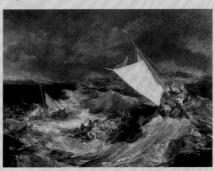

The Shipwreck (1805), oil on canvas, 170.5 × 241.5 cm, Tate Britain, London

Patrons, Patriotism and Poetry

Back in the mountains _ It would be seventeen years before Turner returned to the Alps, but his many sketches and the deep impression the scenery had made on him would supply the artist with enough material for many paintings. During his journey he had suffered "much fatigue from walking, and often experienced bad living and lodging." However, he made more than four hundred drawings of the romantic scenery in six sketchbooks. In *The Passage of Mount St Gothard taken from the centre of the Teufels Broch* of 1804 (see p. 22), the viewer shares Turner's feeling of fear and awe, accentuated by the vertical composition and virtually monochrome palette of the painting.

On the move _ Turner's mother died on 15 April 1804. After her death, his father became the artist's 'studio assistant', living with him in Harley Street, and subsequently in Turner's other homes. At around this time Turner took a pied-à-terre on the Thames in Isleworth and, in October 1806, he rented a property in Hammersmith. He retained his London home, although he moved away from Harley Street in 1810 just around the corner to Queen Anne Street West. This succession of moves continued until Turner's new house in Twickenham had been built. Solus Lodge (later called Sandycombe Lodge; see back flap) was completed to the artist's own designs in 1813, possibly with the assistance of John Soane. Turner had always had a lasting affection for the westerly reaches of the Thames, which may have stemmed from childhood days in Brentford where he went to school.

Patriotism and personality clashes _ Maritime subjects constitute an important part of Turner's work and, in 1805, he painted *The Battle of Trafalgar as seen from the Mizen Starboard Shrouds of the 'Victory'*, based on sketches he had made of the ship, with Nelson's

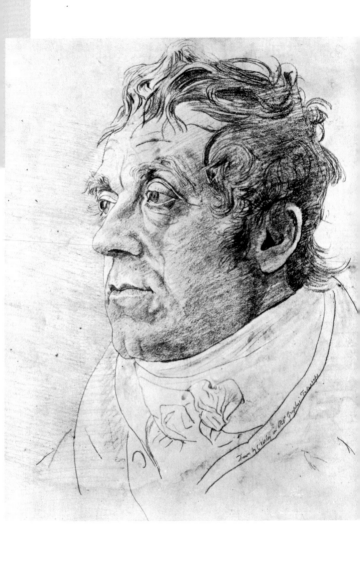

One of the very few portraits of Turner

Charles Turner, J.M.W. Turner, Pencil, The National Portrait Gallery, London

The Passage of Mount St Gothard taken from the centre of the Teufels Broch (Devil's Bridge), Switzerland (1804), watercolour, 98.5 × 68.5 cm, Abbot Hall Art Gallery, Kendal

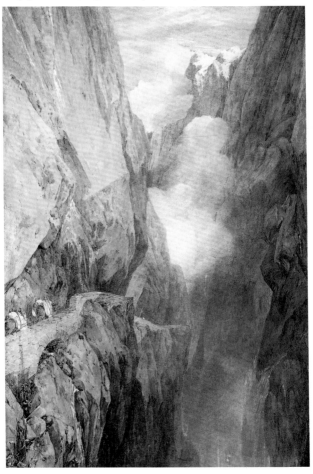

body still on board, as she entered the Medway. Turner was patrioti-
cally interested in English naval history and depicted this unusual
scene of the battle still in progress, in considerable detail. He exhib-
ited the painting in an unfinished state in a private gallery that he
had set up in 1804, and it was not until 1808 that the completed paint-
ing was exhibited at the British Institution.

Amidst the mass of sails: Nelson lies mortally wounded

The Battle of Trafalgar as seen from the Mizen Starboard Shrouds of the 'Victory'
(exhib. 1806), oil on canvas, 171 × 239 cm, Tate Britain, London

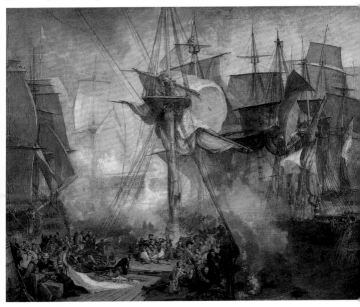

Despite having opened his own gallery in the house next door, Turner continued to send paintings to the Royal Academy exhibitions, except in 1805, when he relied totally on the sales of pictures on display in his own gallery. Since becoming a full Academician, Turner had involved himself closely with institutional activities but had fallen out with Sir Francis Bourgeois, Landscape Painter to the King, who had insulted Turner, calling him a 'little reptile'. On being told on another occasion that his behaviour had been the cause of complaint to the whole Academy, Turner was sufficiently offended as to stay away for some time. Nevertheless, his loyalties remained to his professional colleagues and friends as well as to his patrons and to the Royal Academy itself, rather than towards members of his own family who he always kept at a discreet distance. It was together with others from his small circle of acquaintances that Turner would go on excursions to Greenwich or Richmond or indulge in one of his favourite hobbies, angling, even taking part in fishing contests.

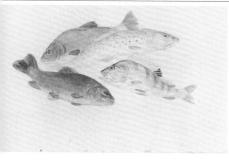

Study of Four Fish (c. 1818),
pencil and watercolour,
27.5 × 47 cm, Tate Britain,
London

Reports by contemporaries suggest that Turner was not an easy person to deal with until his trust had been won. The nineteenth-century English author and art critic, John Ruskin, described Turner as "a somewhat eccentric, keen-mannered, matter-of-fact, English-minded gentleman: [both] good-natured [and] bad-tempered, hating humbug of all sorts, shrewd, perhaps a little selfish, [and] highly intellectual, the powers of his mind ... flashing out occasionally in a word or a look."

Childhood memories of the Thames

Sun Rising through Vapour: Fishermen Cleaning and Selling Fish (1807), oil on canvas, 134.5 × 179 cm, The National Gallery, London

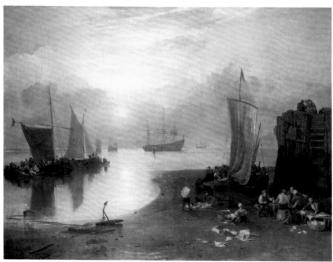

Turner's only completed painting of his town of birth
London (exhib. 1809), oil on canvas, 90.2 × 120 cm, Tate Britain, London

Professorship _ In 1807, Turner launched the first issue of *Liber studiorum* and put his name forward for the post of Professor of Perspective to the Academy, to which he was promptly elected. As Turner's schooling had been rather rudimentary, he had to prepare himself carefully for the first series of lectures which was held in early 1811. Turner illustrated them with his own watercolours and diagrams that were much admired, although the lectures themselves were ridiculed for their awkwardness of expression, some pupils complaining that "half of each lecture was delivered to the attendant behind him."

Liber studiorum _ This was a long series of plates

after Turner's own designs and modelled on Claude's *Liber veritatis*, published in the late 1770s. Turner himself etched the majority of the subjects in outline which were then mezzotinted by Charles Turner (no relation) among others. The fourteen parts, which appeared irregularly until 1819, each contained five plates, divided into the following categories: historical, mountainous, pastoral, marine and architectural. *Liber studiorum* was a conscious advertisement of Turner's range of works.

Snow Storm: Hannibal and his Army crossing the Alps (exhib. 1812), oil on canvas, 146 × 237.5 cm, Tate Britain, London

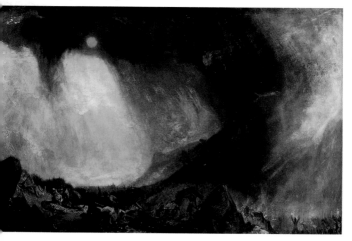

In the period of thirty-one years in which he held this office, Turner only gave his lecture series twelve times, while obstinately clinging to the title.

Tours of England _ In the summer of 1809 Turner was invited to Petworth House, Lord Egremont's country seat in West Sussex, for the first time, and was to be a regular visitor until 1837. This was a period in which he first visited several important patrons and, although he never strove for social acceptance in elegant society, many of his aristocratic patrons became long-standing friends. Among these was Walter Fawkes, whom Turner continued to visit in his Yorkshire home nearly every year until 1824. On one such visit, Fawkes' son, watching Turner paint a maritime scene, recorded the artist's unconventional working methods as follows: "He began by pouring wet paint until [the paper] was saturated. He tore, scratched [and] scrubbed at it in a kind of frenzy and the whole thing was chaos – but gradually and as if by magic the lovely ship, with all its exquisite minutiae, came into being and by luncheon time the drawing was taken down in triumph."

From July to September 1811, Turner toured Dorset, Devon, Cornwall and Somerset in connection with *The Southern Coast* – his first major series of topographical engravings to be published in book form.

It comprised eighty plates by several different engravers, Turner having already built up a team of competent engravers whom he had trained to interpret his watercolours. The idea for such series was pursued by the artist in his maturity, culminating in his highly acclaimed work *Picturesque Views in England and Wales* (see p. 36)

Turner the poet _ Inspired by the success of another member of the Academy, Turner attempted to show his hand at a different medium in the first decade of the nineteenth century – namely poetry. From 1798 onwards, the Royal Academy permitted the addition of verses and quotations to accompany exhibited works, and Milton and Byron, as well as Thomson's *The Seasons*, became a popular source of inspiration for Turner, many of the quotations referring to the effects of light.

In 1812 Turner completed his important historical painting *Snow Storm: Hannibal and his Army crossing the Alps*. Often regarded as a key picture in his development, it was accompanied by his own verses in the Royal Academy catalogue. These came from his work *Fallacies of Hope*, fragments of which Turner was frequently to add to selected

Not Italy but Devon: the Tamar Valley

Crossing the Brook (1815), oil on canvas, 193 × 165 cm, Tate Britain, London

Country Blacksmith Disput-
ing upon the Price of Iron,
and the Price charged to
the Butcher for Shoeing his
Poney (1807), oil on canvas,
55 × 78 cm, Tate Britain,
London

exhibits throughout his life, but the poem was never published as a whole. In other poems, his verses are sometimes contrived and reveal the artist's uncertainty of diction. He was, however, obviously well aware of his own shortcomings and wryly added the following lines to his work *Garreteer's Petition* depicting an uninspired poet: "Aid me, ye Powers! O bid my thoughts to roll / In quick succession, animate my soul / Descend my Muse, and every thought refine, / And finish well my long, my *long-sought* line."

Reaction to other artists and events _ Turner's painting was also effected by the success of others who had modelled their work on the rustic interiors of Dutch genre painters. A succession of 'replies' to fellow-artists ensued, such as *Country Blacksmith Disputing with the Butcher upon the Price of Iron, and the Price Charged to the Butcher for Shoeing his Poney*. Turner was highly susceptible to stimuli of this

John Constable _ Unlike Turner, who travelled around the country and across the Continent with his sketchbook, the English landscape painter John Constable (1776–1837) found his motifs within a few miles of his Suffolk home. His work was more popular in France than in England at that time and influenced the artists of the Barbizon School and Eugène Delacroix. Among his most famous works are *The Hay Wain* and *Flatford Mill*.

"The rigid hoar frost melts before his beam"

Frosty Morning (exhib. 1813), oil on canvas, 113.7 × 174.6 cm, Tate Britain, London

kind and, throughout his career, was always ready to imitate the subject matter and occasionally the manner of a successful contemporary.

From the 1810s onwards, Turner's pictures became increasingly light in tonality. He toured the West Country in 1811 and 1813 before returning to the North of England, as every year, to visit Fawkes who gradually assembled an unparalleled collection of paintings and watercolours by the artist. *Frosty Morning*, which was extremely well received by the critics and public alike when exhibited in 1813, is based on one of Turner's journeys to Yorkshire and shows the start of a bitterly cold, but sunny, winter's day. It was reputed to be one of Turner's favourite paintings and immortalised the artist's "old crop-eared bay horse, or rather a cross between a horse and a pony." The figure of the young girl is also said to resemble one of Turner's daughters.

It was also in 1813 that Turner and Constable met for the first time. The well-documented occasion was a dinner held at the Royal Academy at which they were seated next to each other. Although each had his own opinion about landscape painting, Constable enjoyed the evening: "I was a good deal entertained with Turner," adding however: "He is uncouth – but has a wonderful range of mind."

Dido Building Carthage; or the Rise

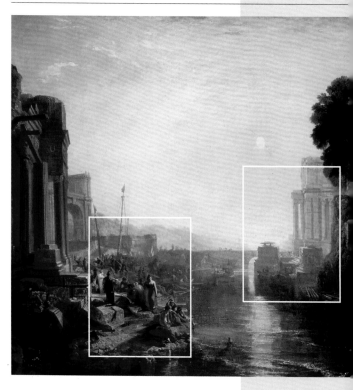

**Dido Building Carthage or the Rise of the
Carthaginian Empire** (1815), oil on canvas,
155.5 × 232 cm, The National Gallery, London

of the Carthaginian Empire

Turner's chef d'œuvre _ The perfection of his treatment of historical themes _ A gift to the Nation

Perhaps the most evolved of Turner's many paraphrases of the Claudian harbour prototype, *Dido Building Carthage*, painted in 1815, formed part of his bequest of works to the Nation in his will of 1831, together with its 'companion' picture *The Decline of the Carthaginian Empire* of 1817.

Although Turner always acknowledged his debt to Claude – and through him to the Italian masters – this work was modelled on seventeenth-century Dutch marine painters. Turner valued this painting above all others he produced and refused to sell it, increasing the price to discourage any potential purchasers.

When exhibited for the first time, the reference: 'Ist book of Virgil's *Aeneid*' was added. The inscription 'Sychaeo' identifies the tomb of Sychaeus, Dido's husband, whose murder at the hands of her brother Pygmalion had led to her fleeing from Tyre to North Africa, where she founded Carthage.

The development of Turner's treatment of historical themes had intensified since he had first started to emulate the works of Poussin in his 'Plague' paintings. Spurred on by the success of his work *Hannibal crossing the Alps*, in which he captured the feeling of danger and fear during a storm in the mountains, Turner also included emotional moments in his Carthaginian subjects.

Both *Dido Building Carthage* and *The Decline of the Carthaginian Empire* unite elements frequently found in other works by the artist as well as by Claude and Poussin, particularly evident in the structured landscape and perspective, the Classical architecture and the play of light and colour. In both cases the viewer looks towards the source of light.

The painting was received very differently by the public. One critic described it as "an admirable production. It is in the grand style, and the effects produced correspond with the classical dignity of the sub-

ject, without departing from some of the most beautiful appearances of nature in the department of landscape." Although this was topped by the eulogy in 'The Morning Chronicle': "One of those sublime achievements which will stand unrivalled by its daring charac-ter," there were also less favourable reactions. The declaration: "Turner did not com-prehend his Art," added to the artist's determination never to part with the painting.

Dido Building Carthage was left to the National Gallery in London on the express condition that it should hang for ever beside two works by Claude, the *Sea Port* and *Mill*. Turner was no doubt rightly confident that the comparison would do him no harm.

In *The Decline of the Carthaginian Empire*, exhibited two years later, the sun is setting on a once great Empire. Turner witnessed the rise and fall of the Napoleonic Empire and this epic painting shows his awareness of the historical parallels and, through them, the tragic nature of the human condition. This comparison was a subject quite frequently chosen by artists in the late eighteenth and early nineteenth centuries – sometimes with a parallel being drawn between Carthage and England. *The Decline of the Carthaginian Empire* was originally intended to accompany *Dido Building Carthage*, but Turner corrected his will, replacing *The Decline* with the earlier painting *Sun Rising through Vapour*.

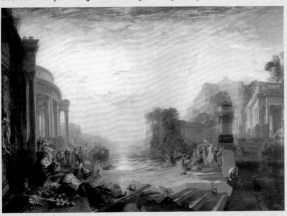

The Decline of the Carthaginian Empire (1817), oil on canvas, 170 × 238.5 cm, Tate Britain, London

To Rome and back

The first trip to Italy _ Glorious England _ Continental travel _
Personal tragedy and new hope _ A maritime masterpiece _
'London's burning'

The first trip to Italy _ The paintings Turner completed after
returning from a journey to Belgium, Holland and up the Rhine
through Germany a couple of years earlier, led to a commission for a
series of watercolours to illustrate James Hakewill's *Picturesque Tour
of Italy*. Turner had wanted to visit Italy for some time and had
already once had to postpone his trip. With the support of his patrons
Sir John Leicester and Walter Fawkes, Turner set out for Italy on a
journey that would last from August 1819 until 1 February 1820.
"Turner should come to Rome," enthused Thomas Lawrence, the
President of the Royal Academy, who was staying in the city at the
time, "the subtle harmony of this atmosphere … can only be rendered
… by the beauty of his tones."

Turner's route took in Turin, Como, Venice, Rome and Naples,
returning via Florence, Turin and the Mont Cenis Pass. In Loreto, he
made a note in his sketchbook: "The first bit of Claude," and jotted
down descriptions of the colours he saw in countryside he was passing
through: "The ground – reddish green-grey and apt to Purple, the Sea
quite Blue, under the sun a warm vapour, from the Sun – Blue reliev-
ing the shadow of the olive trees, dark, while the foliage, light, or the
whole – when in shadow – a quiet Grey." But Turner did not just go in
search of scenery. He was interested in the country's history and the
paintings of the Italian masters.

Turner's experience of the Mediterranean light first hand resulted
in an increasingly brightly-coloured palette, dominated by chrome
and cadmium yellows, vermilion and white. Back in England, Turner's
daring attempts at capturing the essence of what he had seen, were
ridiculed by critics who nicknamed his works the 'yellow fever' paint-
ings. The artist's colours, however, were actually constructed on a
carefully thought-through chromatic plan based on contrasting fields

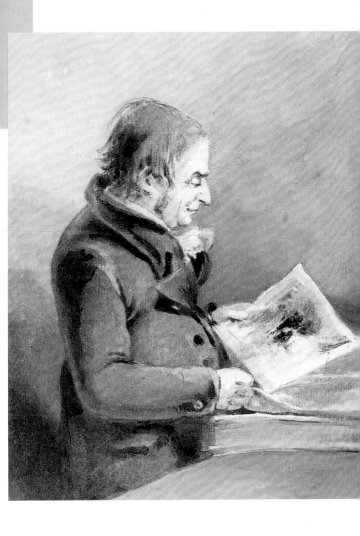

A life devoted to art

J.T. Smith, **Joseph Mallord Turner in the Print Room in the British Museum** (*c.* 1825), pencil and watercolour, 22.2 × 18.2 cm, The British Museum, London

Venice: Looking East to the Giudecca (1819), watercolour, 22.4 × 28.7 cm, Tate Britain, London

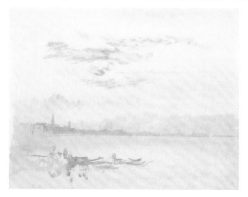

of complementary colours, often ochre or an earth tone, and indigo or anther shade of blue.

The excitement Turner felt when admiring the works of the great Renaissance painters is reflected in his perspective landscape *Raffaelle accompanied by La Fornarina, preparing his Pictures for the Decoration of the Loggia*, which was exhibited at the Royal Academy in 1820. In this large canvas, Turner pays tribute to the Italian master and the whole city of Rome as a treasure house of art, identifying himself explicitly with the European tradition.

Glorious England _ Back in England, Turner continued to further his painting techniques, experimenting with the interaction of oil and

Picturesque Views _ *Turner's Picturesque Views in England and Wales, 1825–1838* was an ambitious series for which the artist created some of his finest watercolours. Although 100 scenes were planned, ninety-six were ultimately engraved. Ruskin described these pictures as representing Turner's "central powers and dominant feelings towards his native country." They include both landscape and maritime scenes and display Turner's extraordinary gift of composition and his subtle use of the human figure. As a whole, the work is an acutely perceptive portrayal of his age.

Where the water meets the sky

S. Giorgio Maggiore: early Morning (1819), watercolour, 22.4 × 28.7 cm, Tate Britain, London

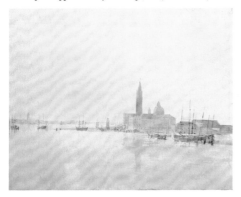

watercolour: watercolour was applied over broadly washed fields of paint with bright areas of saturated colour – an effect best seen in the series of views of the *Rivers of England and Wales* published in the 1820s. For his last major topographical project – the more famous *Picturesque Views in England and Wales* – Turner relied heavily on drawings he had made back in the 1790s, although he did visit a number of new places.

Turner rarely worked directly from his motifs in colour. Instead he preferred "to make fifteen or sixteen pencil sketches to one coloured one" because "it would take up too much time to colour in the open air." He did, however, make preliminary sketches in which he defined

A complex lesson in perspective and art history

Rome, from the Vatican. Raffaelle, accompanied by La Fornarina, preparing his Pictures for the Decoration of the Loggia (1820), 177.2 × 333.5 cm, Tate Britain, London

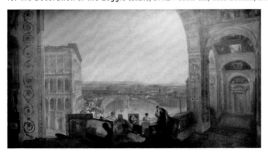

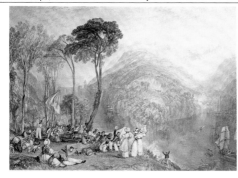

Dartmouth Cove, with
Sailor's Wedding
(c. 1828), watercolour,
28 × 40 cm,
private collection

the general areas of colour, only occasionally working from nature in
oil. He kept most of his drafts in clearly marked sketchbooks, some-
times referring back to them many years later.

Continental travel _ In 1820 Turner enlarged his London house and
built a new gallery. The following summer, he travelled to Paris,
Rouen and Dieppe, while his journeys in 1822 took him by boat up the
east coast of Britain, his destination being Edinburgh. Other trips over
the next few years were to the east of England and along the south
coast, across the Channel to Holland and Belgium, up the Rhine again
in 1825, and to France the following year. In France he completed a
series of views of the Loire and the Seine which were published
around 1833–35. For these he adopted a smaller format and used
gouache instead of watercolour to increase the intensity of the colours.

Romantically hidden in the Black Mountains in Wales

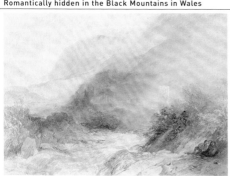

Llantony Abbey, Mon-
mouthshire (c. 1828),
watercolour, 29 × 43 cm,
Indianapolis Museum
of Art

Form, light and colour: the three main ingredients in Turner's works

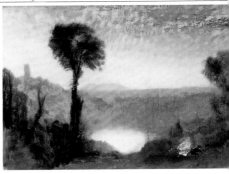

Lake Nemi (*c.* 1828), oil on canvas, 60.3 × 99.7 cm, Tate Britain, London

It was while Turner was returning from one of his many trips abroad, that a fellow traveller wrote a vivid account of the journey, mentioning: "I have fortunately met with a good-tempered, funny little man ... He is continually popping his head out of the window to sketch whatever strikes his fancy ... He speaks but a few words of Italian, about as much of French, which two languages he jumbles together most amusingly. His good temper, however, carries him through all his trouble ..."

Some time earlier, in 1828, Turner established a studio in Rome and produced a number of oil sketches and finished pictures that were generally received with incomprehension and, in some cases, with disgust. His outstanding painting *Ulysses deriding Polyphemus* seems to have its origins in Rome, but also reflects the artist's continuing

The Dance of Death: the light of the sun absorbs its victims

Death on a pale Horse (*c.* 1825/30), oil on canvas, 59.7 × 75.6 cm, Tate Britain, London

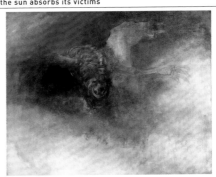

experiments in watercolour and 'a kind of tempera' during the late 1820s. His style reflects the influence of fresco painting as well as that of the Nazarenes who were active in Rome at that time. Their love of outline and cold colour would later reach England and render Turner's own style of painting outdated. The composition is based on a drawing made some twenty years earlier, but the treatment of light and richness of colour clearly reflect the influence of Rome.

Turner's interpretation of a classical story

Ulysses deriding Polyphemus (1829), oil on canvas, 132.5 × 203 cm, The National Gallery, London

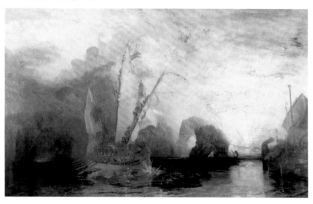

Personal tragedy and new hope _ Turner kept his room in Rome, intending to return the following year, but concerns about his father's health prevented him from travelling. On 21 September 1829, Turner's father died. He was eighty-five. His death was a deeply disturbing experience for the artist and precipitated an increasing sense of isolation, intensified by the indifference and lack of support he encountered at the Royal Academy in conjunction with his nomination for the position of President, following Lawrence's death. Turner found solace at Petworth and, over the next few years, he was a regular guest of Lord Egremont's. Turner received an important commission to paint four decorative panels for the dining room and made a number of intimate sketches of interior scenes. The style of these paintings recurs much later in *A Music Party*, painted in 1835, when Turner was invited to stay with John Nash at East Cowes Castle on the Isle of Wight.

One of several sketches of the interior at Lord Egremont's home

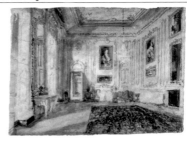

Petworth House: The White and Gold Room (1827), watercolour and gouache on blue paper, 13.4 × 19.1 cm, Tate Britain, London

When not invited to his patrons' houses, Turner frequently stayed in Margate in the lodgings of Mrs Sophia Caroline Booth, who became a close confidante. Following the death of her husband in the early 1830s, a relationship developed between Turner and Sophia Booth which was to last until his death.

A maritime masterpiece _ Turner had always been fascinated by the sea. In his mature years, he became increasingly preoccupied with it as one of the most powerful embodiments of the forces of nature. In the late summer of 1831, Turner was invited to Abbotsford, the home

The atmospheric use of light and colour

A Music Party, East Cowes Castle (c. 1835), oil on canvas, 121.3 × 90.5 cm, Tate Britain, London

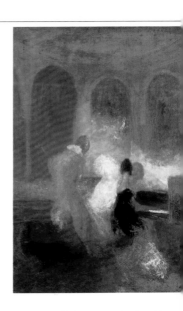

Staffa. Fingal's Cave (1832), oil on canvas, 91.5 × 122 cm, Yale Center for British Art,
Paul Mellon Collection

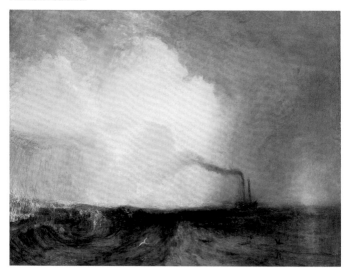

of the Scottish novelist and poet Sir Walter Scott in connection with a
project to illustrate his poems. The two men were very different char-
acters and Scott wrote: "Turner's palm is as itchy as his fingers are
ingenious and he will, take my word for it, do nothing without cash and
anything for it." It is perhaps more realistic to say that Turner was
cautious in his handling of business deals – something he had learned
from his father. He carefully invested his earnings in Government
stocks and in property, establishing a considerable fortune during his
lifetime. Combined with his natural reticence, this led to his being
regarded as miserly.

Despite Turner's initial reluctance even to make the journey to
Scotland, once there he seized the opportunity to visit the Western
Isles and took the steamer to Staffa. The weather was bad and Turner
had to scramble over the rocks to reach Fingal's Cave. Based on his
extraordinary memory for details, he was able to paint *Staffa. Fingal's
Cave* upon his return to London, exhibiting the work at the Royal
Academy in 1832. It is arguably the most perfect expression of his
romanticism. Turner recalled the event as follows: "The sun getting

towards the horizon, burst through the rain-cloud, angry, and for wind." The painting was well received at the Academy and was the first painting by Turner to go to the United States. It remained unsold for thirteen years, before being acquired by James Lenox for £500. On hearing that the new owner was disappointed at its 'indistinctness', Turner replied: "You should tell him that indistinctness is my *forte*."

'London's burning' – The inferno at the old Houses of Parliament on 16 October 1834 was an event that deeply effected Turner. He was one of the many thousands to witness the fire personally and made a number of quick watercolours to capture the scene. Generally, he did not like being observed when sketching, but the importance of this occasion was overriding. Not only was the scene dramatic, but for Turner it was a very personal loss. The Houses of Parliament were indelibly linked to his childhood memories and the horror at seeing their destruction is reflected in the two paintings he later completed in oil. Turner's fascination with light and colour could be given free reign. This fascination was to reach its climax in the paintings he made during the last decade of his life.

The sky and the Thames are alight with the colours of the blaze
The Burning of the House of Lords and Commons, October 16, 1834 (1834), oil on canvas, 92.5 × 123 cm, The Cleveland Museum of Art, Ohio

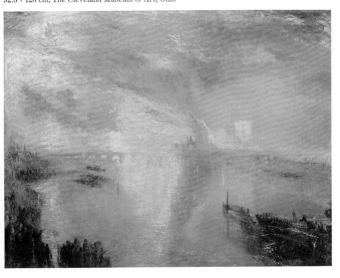

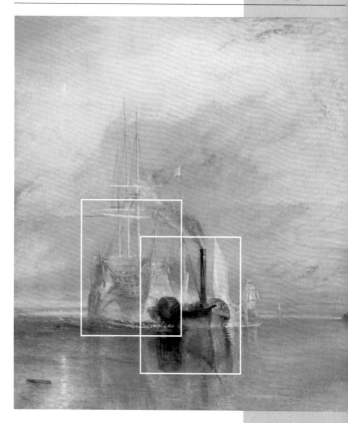

The Fighting 'Temeraire' tugged to her Last Berth to be broken up (1838), oil on canvas, 91 × 122 cm, The National Gallery, London

...er Last Berth to be broken up

A moving tribute _ The end of an era _ A counterbalance to 'Peace: Burial at Sea'

Patriotism, maritime history and an emotional farewell to an era are brought together in this work which Turner referred to as 'my Darling'. Painted in 1838, it depicts the great warship 'Temeraire' on her way to the scrap-yard. The 'Temeraire' – a ninety-eight-gun ship that had fought beside Nelson's 'Victory' at Trafalgar – was launched in 1798. Built of over 5,000 oaks and manned by more than 750 men, she had long been relegated to other duties. The Napoleonic wars ended in 1815 and by 1838, the forty-year old vessel was in a poor state of repair. She was stripped of reusable material and sold for the value of her timbers to a ship-breaker.

Her final journey was anything but glorious – a massive hulk largely devoid of her rigging, with her sails furled – yet Turner's depiction of the powerless vessel being towed by a steam tug is a magnificent and deeply symbolic painting.

Turner transformed harsh reality into an emotional elegy, freely adapting facts to create the desired effect. The sunset, enveloping the whole painting, stands for the end of an era. It is, however, also a reflection on the transience of mankind.

Rivers and the open sea played a pivotal role in Turner's art. There was nothing exceptional about this scene as such, which remained largely

unobserved by his contemporaries. Turner, however, transformed it into a poetic canvas of such impact that the English novelist William Makepeace Thackeray likened *The Fighting 'Temeraire'* to "a magnificent national ode, or piece of music." Ten days after the painting was first exhibited, one critic declared *The Fighting 'Temeraire'* to be "the most wonderful of all the works of the greatest master of the age."

Turner relies on colour to illustrate the ship's fate. The pale shades used for the skeletal ship emphasise the ghostly stillness. Her original black and yellow paint is not visible at all and, where the flag once flew, only the smoke from the tug is now to be seen. Ignoring the conventions of contemporary steamboat design, Turner positioned the tug's funnel as far forward as possible in order to intensify the effect of the smoke.

No preliminary sketches or studies for this picture are known. However, many elements in this work can be found in other paintings.

The blazing sunset, occupying almost half the picture, bathes the scene in shades of red – with both the sky and the water taking on the same colour. The rising or setting sun was one of Turner's favourite motifs;

the reds and oranges can also be found in the flames leaping into the sky in *The Burning of the House of Lords and Commons* (see p. 43) and the watercolour of the same scene, painted just four years earlier. Steamboats also feature in a number of works, for example in *Snow Storm – Steam-boat off a Harbour's Mouth* or *Staffa. Fingal's Cave* (see pp. 54, 42). The black smoke rising from the steamship in *Peace: Burial at Sea* (see p. 55), however, symbolises the loss of a dear friend, in *The Fighting 'Temeraire'* it is merely the passing of a ship.

In the background, the sailing ships disappearing into the far distance, add to the feeling of solitude. Apart from the ripples coming from the

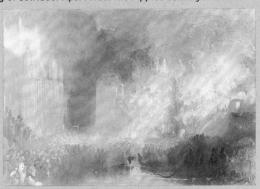

tug, the water is calm – a great ship is being left to its fate.

The Burning of the Houses of Parliament (1834), watercolour, 30.2 × 44.4 cm, Tate Britain, London

Light and Colour

**Dramatic effects _ In defence of a genius _ Return to Venice _
Masterpieces of light and colour _ Painting on the spot _
Final journeys _ Contested wills and the artist's bequest**

Dramatic effects _ The late works, in which Turner took the expressive power of his techniques to an extreme, reveal his extraordinary talent most clearly. Only after the emergence of abstract painting during the twentieth century did much of Turner's work become widely understood, confirming his position as one of the greatest English painters of all time. His late explorations with light and colour, combined with dramatic effects, led to the artist's paintings being interpreted as Impressionist in style. In reality, however, Turner remained true to earlier concepts of great art.

In defence of a genius _ On 22 June 1840, Turner met the English author and art critic John Ruskin for the first time. Ruskin recorded this meeting in his diary as follows: "Everybody had described [Turner] to me as boorish, unintellectual, vulgar. This I knew to be impossible." In 1843 Ruskin published the first volume of *Modern Painters*, a survey of landscape painting that was not completed until 1860. Intended as a defence of Turner's genius, Ruskin had started to admire his work many years earlier and the publication caused a revival in interest in Turner's paintings.

Return to Venice _ Although already sixty-five, Turner embarked on his third visit to Venice in August 1840. This took in Rotterdam and the towns along the Rhine, as well as Munich and Coburg on the journey home. The following year he returned to Switzerland, to Lucerne and Zurich, also painting scenes along the shores of Lake Constance including the German town of the same name (see p. 51).

Masterpieces of light and colour _ Always sensitive to the deaths of other Academicians and patrons such as Lord Egremont, Turner felt an increasing sense of isolation. To commemorate the death of his friend and rival David Wilkie at sea on his return from the Near East, Turner painted *Peace: Burial at Sea* (see p. 55). It is a powerfully evocative

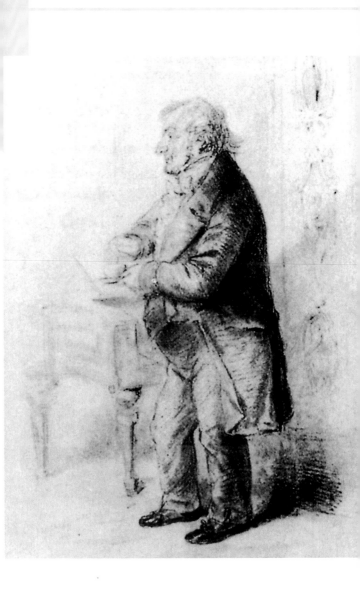

The elderly artist relaxing with a cup of tea

Alfred d'Orsay, William Turner during a "Conversazione" (c. 1850), lithograph, private collection

Sun setting over a Lake (*c.* 1840), oil on canvas, 91.1 × 122.6 cm,
Tate Britain, London

work painted "as it must have appeared off the coast," as Turner wrote
later. The intensity of the light in the middle of the painting, focusing
on the coffin as it is lowered into the sea, is contrasted by the sombre
silhouettes of the ships and sails. In response to the remarks of a critic
who declared that the sails were too black, Turner said: "I only wish I

Capturing a brief moment on canvas

Norham Castle,
Sunrise (*c.* 1840–45),
oil on canvas,
91 × 122 cm, Tate
Britain, London

A delicate composition perfectly capturing the atmosphere

The Dogano, San Giorgio, Citella, from the Steps of the Europa (1842), oil on canvas, 61.6 × 92.7 cm, Tate Britain, London

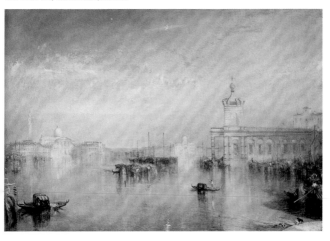

had any colour to make them blacker." The picture can be considered a counter-piece to *The Fighting Temeraire* (see p. 45 ff) – however, with a human loss replacing that of a ship. When the painting was exhibited, Turner chose to hang it together with a picture of Napoleon in exile entitled *War: The Exile and the Rock Limpet*.

One of many watercolours painted in Germany

Constance (c. 1841), watercolour, 24.2 × 31.1 cm, Tate Britain, London

Shade and Darkness: The Evening of the Deluge (*c.* 1843), oil on canvas, 76 × 76 cm, The National Gallery of Art, Timken Collection, Washington D.C.

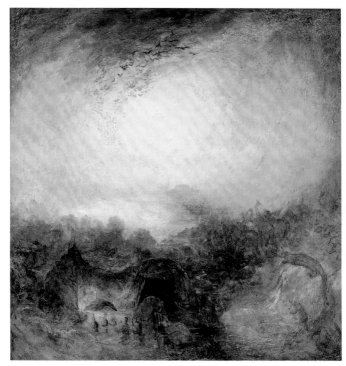

Turner displayed another set of 'coupled pictures': *Shade and Darkness: The Evening of the Deluge* and *Light and Colour (Goethe's Theory): The Morning after the Deluge – Moses Writing the Book of Genesis*, in which the artist put Goethe's colour theory into practice, emphasising the emotional connotation of colour. The immediate occasion for this was the publication of Goethe's theoretical work in English in 1840. Turner's copy is full of notes and comments. He obviously analysed these notions with the same concentration as he had approached the theory of perspectives. The dominance that Goethe assigned to yellow found direct parallels in Turner's paintings. Turner had progressed from darker tones – the 'minus' colours in Goethe's work – to his use of pure colour for its psychological effects.

Turner's interest in modern industrial and technological subjects is demonstrated in *Rain, Steam and Speed: The Great Western Railway* (see p. 59 ff), which is a radical re-interpretation of the Classical landscapes painted by Poussin. Turner took this to an extreme in his painting *Snow Storm: Steamboat off a Harbour's Mouth* (see p. 54) which was described in 1842 as 'a mass of soap-suds and whitewash'. According to Turner's own account of the event, he was lashed to the mast of the vessel to experience the force of nature first hand, and painted the storm "to show what such a scene was like." Gombrich calls it "one of Turner's most daring paintings" which, compared to the works of other artists, shows the "measure of the boldness of Turner's approach." In Dutch paintings of ships in storms, the details are generally clearly discernible; in Turner's painting he creates an impression of the scene and most, if not all details, are swallowed up by the bright light or dark shadows.

... extending the cosmological range of his art

Light and Colour (Goethe's Theory): The Morning after the Deluge – Moses Writing the Book of Genesis (1843), oil on canvas, 78.5 × 78.5 cm, Tate Britain, London

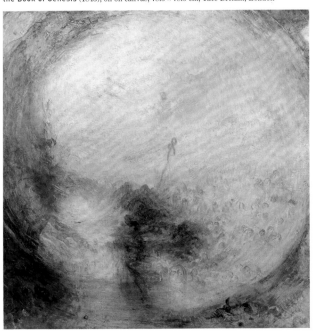

Snow Storm: Steamboat off a Harbour's Mouth making Signals in shallow Water, and going by the Lead. The Author was in this Storm in the Night the Ariel left Harwich (1842), oil on canvas, 91.4 × 121.9 cm, Tate Britain, London

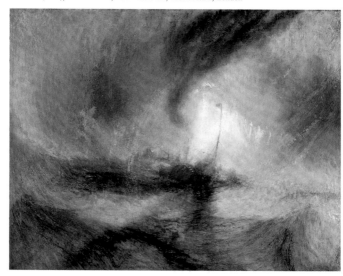

Painting on the spot _ The 'Varnishing Days' at the Royal Academy were an interesting phenomenon. These well-documented events can perhaps best be compared with the 'happenings' of modern artists. Over a period of several days before the opening of an exhibition, Turner would complete his paintings *in situ*. This unique display of his genius was much admired by many colleagues. One contemporary described it as follows: "Turner used to send pictures into the Academy with only a delicate effect, almost in monochrome, laid onto the canvas, and very beautiful they looked, often like milky ghosts. They had probably been painted for some time, as they were quite dry and hard; all the bright colour was loaded on afterwards, the pictures gradually growing stronger during the three varnishing days."

Final journeys _ Turner continued to produce a large quantity of work and the tours of the 1840s indeed produced some of his most inspired watercolours. His last trips to the Continent were brief excursions to the Normandy coast in 1845, taking in Bologne and its environs, and Dieppe and the coast of Picardy in September and

October 1846. His health was failing and he was advised to restrict the length of his strenuous journeys.

When seventy years old, Turner, as the oldest Academician, assumed the duties of the President of the Royal Academy following the illness of Sir Martin Archer Shee. By now he was a frail man who was seldom seen in public and, since the loss of his teeth, he was reluctant to dine out. He spent most of his time with Sophia Booth, often passing by the name of Admiral Booth. In 1846 or possibly earlier, Turner brought Sophia to London to act as his housekeeper. She lived in Davis Place, Cremone New Road, Chelsea, to which he retreated secretly, and it was here that he died on 19 December 1851. The doctor who was present at his death, recorded: "Just before 9 a.m. the sun burst forth and shone directly on him with that brilliancy which he loved to gaze on. He died without a groan …" It is reputed that his last words were:

One of Turner's true masterpieces

Peace: Burial at Sea (1842), oil on canvas, 87 × 86.7 cm, Tate Britain, London

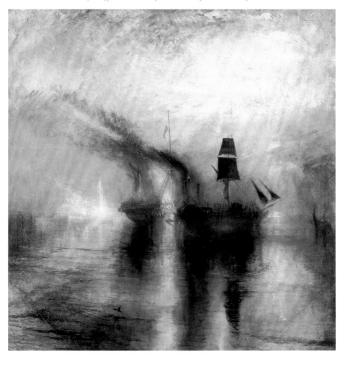

Landscape with Water: Tivoli (*c.* 1840), oil on canvas, 121.9 × 182.2 cm, Tate Britain, London

"The Sun is God." Turner was buried with great pomp in the crypt of St Paul's Cathedral on 30 December, next to the tombs of Reynolds and Lawrence, as he had wished.

Contested wills and the artist's bequest _ Turner had perceived his output as rivalling in range and quantity to the national collection of Old Masters and his finished works include tributes to Titian, van Dyck, Poussin, Ruisdael, Watteau and Canaletto, to mention just a few. Generally speaking he did not paint his works to sell – in fact he went to great lengths to repurchase works that came onto the market and, in his revised will, he determined to leave his finished oil paintings to the Nation.

His London house at 47, Queen Anne Street West had become the home of Hannah Danby who remained there until the 1860s, apparently having lost contact with Turner. His daughter Georgina, seems to have died shortly after her father; Evelina married a diplomat and lived abroad.

Almost immediately after Turner's death, his will was contested by his family and later modified by various codicils, the last in 1849, in which Hannah Danby and Sophia Booth were both granted annuities. All original works remaining in the artist's possession (and not just the

finished works the artist had stipulated) were to go to the National Gallery, while the large sums of money (around £140,000 in total) were divided among the heirs. Turner himself had requested that the money be used to found a school for English landscape artists, to be established on a site he had acquired in Twickenham. Secondly, he wished to endow a professorship in landscape painting at the Royal Academy. These two plans were close to his heart, especially bearing in mind how he had regarded his colleagues as his family.

The art historian E. H. Gombrich wrote: "Turner crowded into his pictures every effect which would make them more striking and more dramatic and, had he been a lesser artist than he was, this desire to impress the public might well have had a disastrous result … Yet he was such a superb stage-manager, he worked with such gusto and skill, that he carried it off and the best of his pictures give us a conception of the grandeur of nature at its most romantic and sublime." The Turner Bequest, comprising some 300 oil paintings on canvas or panel and over 20,000 drawings, including the contents of nearly 300 sketchbooks, bears witness to this skill and to the artist's overall genius. His position among the greatest landscape painters of all time is uncontested.

The artist's genius seen in a few simple brushstrokes

From Turner's **Ideas of Folkstone sketchbook** (1845), watercolour, 23 × 32.4 cm, Tate Britain, London

Rain, Steam and Speed

Rain, Steam and Speed: The Great Western Railway (1844),
oil on canvas, 91 × 122 cm, The National Gallery, London

The Great Western Railway

**Technological advances _ Exposed to the elements _
Light, colour and perspective**

"Turner has made a picture with real rain, behind which
is real sunshine, and you expect a rainbow every
minute. Meanwhile there comes a train down upon you,
really moving at the rate of fifty miles an hour ..." wrote
Thackeray in 1844, the year *Rain, Steam and Speed: The
Great Western Railway* was exhibited. Turner showed
this painting at the Royal Academy together with three
scenes of Venice and three seascapes.

The work is not intended solely to be a view of the
Great Western Railway but, as the title of the work
implies, an allegory of the forces of nature. Turner
wanted to experience the elements first hand, much to
the bewilderment of a friend of Ruskin's. This friend
reported that, while travelling on the London to Exeter
train, "an elderly gentleman asked if he could open the
window. He stood there with his face exposed to the
rainstorm for nine minutes, observing every detail and
committing them to memory." Just as Turner had been lashed to the
mast in the middle of a storm at sea to experience the forces of nature
in *Snow Storm: Steam Boat off a Harbour's Mouth*, so he hung his head
out of the train window in the rain before painting *Rain, Steam and
Speed*.

The railway was nothing new at that time. By 1843 more than 2,000
miles of track had been laid in England and within the next four years
a further 3,000 miles were to be added. The bridge, however, had only
recently been completed bridge. The great double-arched Maidenhead
Bridge was built by Isambard Kingdom Brunel in 1837–38. Brunel, who
had married into the family of a friend of Turner's, had been chief en-
gineer of the Great Western Railway since 1833. It was a time of rapidly
increasing mechanisation and a number of ground-breaking engineering

feats were accomplished by Brunel, including the construction of famous ocean-going steam ships such as the SS The Great Western.

The painting is dominated by the jetty-like form of the bridge, a device that had been used in other works such as *Juliet and her Nurse* and a second version of *The Burning of the Houses of Parliament*. From the perspective of the viewer, the eye is drawn over the bridge into the bright background and is counterbalanced by the bridge on the left and the indistinct but strongly coloured slope of fields and woods in-between. The areas of landscape seem to dissolve into fleeting impressions, clouded by smoke and shrouded in a veil of rain, as the train speeds by – a view similar to that the passengers would have seen.

The engine is actually an accurate portrait of the 'Firefly' class of engines designed for the Great Western Railway. The passengers are travelling third-class and are shown sitting on benches in open carriages; coaches only being provided for first-class passengers.

Although the Great Western expresses could reach speeds of between 55–60 m.p.h. in 1844 on the long level stretch between Paddington and Swindon, on which the bridge is located, Turner added an amusing anecdote. It is an 'emblem of natural speed' in the form of a hare running along in front of the engine, indicating the engine's limitations. The hare is difficult to see in the painting, but is clearly visible in the engraving made of the picture for 'The Turner Gallery'.

Although Thackeray described the execution of the painting in rather unflattering terms, writing: "The rain is composed of dabs of dirty putty slapped on to the canvas with a trowel; the sunshine scintillates out of very thick, smeary lumps of chrome yellow," he concluded with words of praise. "The world has never seen anything like this picture." And that was true.

Where can Turner's works be seen?

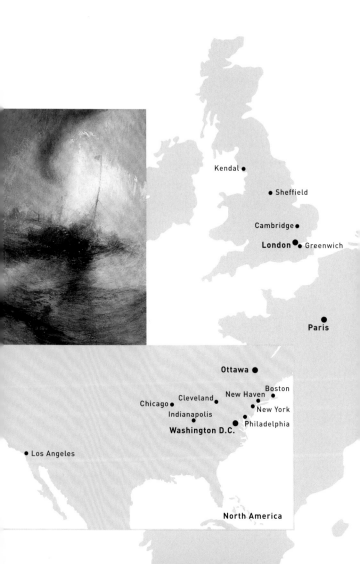

Kendal ●

● Sheffield

Cambridge ●

London ●● Greenwich

Paris ●

Ottawa ●

Boston ●
Cleveland ● New Haven ●
Chicago ●
Indianapolis ● New York ●
Washington D.C. ● Philadelphia

● Los Angeles

North America

● Munich

A selection of museums housing some of Turner's most famous works:

Boston
Museum of Fine Arts
Avenue of the Arts
465 Huntington Avenue
www.mfa.org

Cambridge
Fitzwilliam Museum
Trumpington Street
www.fitzmuseum.cam.ac.uk

Chicago, Illinois
The Art Institute of Chicago
111 South Michigan Avenue
www.artic.edu

Cleveland, Ohio
The Cleveland Museum of Art
11150 East Boulevard
www.clevelandart.org

Greenwich
National Maritime Museum
Park Row
www.nmm.ac.uk

Indianapolis, Indiana
Indianapolis Museum of Art
4000 Michigan Road
www.ima-art.org

Kendal
Abbot Hall Art Gallery
www.abbothall.org.uk

London
British Museum
Great Russell Street
www.thebritishmuseum.ac.uk

National Gallery
Trafalgar Square
www.nationalgallery.org.uk

National Portrait Gallery
St Martin's Place
www.npg.org.uk

Royal Academy of Arts
Burlington House
Piccadilly
www.royalacademy.org.uk

Tate Britain
Millbank
www.tate.org.uk

Victoria and Albert Museum
Cromwell Road
www.vam.ac.uk

Wallace Collection
Hertford House
Manchester Square
www.wallacecollection.org

Los Angeles
The J. Paul Getty Museum
1200 Getty Center Drive
www.getty.edu

Munich
Bayerische Staatsgemälde-
Sammlungen,
Neue Pinakothek
Barer Strasse 29
www.pinakothek.de

New Haven, Connecticut
Yale Center for British Art
1080 Chapel Street
www.yale.edu/ycba/

New York
The Frick Collection
1 East 70th Street
www.frick.org

Metropolitan Museum of Art
1000 5th Avenue and
22nd Street
www.metmuseum.org

Ottawa
National Gallery of Canada
380 Sussex Drive
www.national.gallery.ca

Paris
Musée d' Orsay
62, Rue de Lille
www.musee-orsay.fr
Musée du Louvre
www.louvre.fr

Philadelphia
Philadelphia Museum of Art
26th Street/Benjamin
Franklin Parkway
www.philamuseum.org

Sheffield
Graves Art Gallery
Surrey Street
www.sheffieldgalleries.org.uk

Washington D. C.
National Gallery of Art
Constitution Avenue
between 3rd and 9th Streets
NW
www.nga.gov

More about Turner: a selection of books on the artist and his work

Literature on J.M.W. Turner and his work is just as multifaceted and extensive as his œuvre itself.

A major **standard work** is Martin Butlin and Evelyn Joll, The Paintings of J.M.W. Turner, New Haven and London 1984 (revised edition). This prize-winning catalogue raisonné of Turner's paintings, published in two volumes, is acknowledged as the most comprehensive and authoritative reference work, providing a visual record of his entire œuvre in oil.

A range of specialist publications analyse works in **other media** such as W.G. Rawlinson, The Engraved Work of J.M.W. Turner, R.A., London 1908–13, published in two volumes or A.J. Finberg, Complete Inventory of the Drawings of the Turner Bequest, also in two volumes, London 1909. By the same author is Turner's Sketches and Drawings, London 1910. Finberg also published on the watercolours at Farnley Hall and takes a critical look at Turner's Venice paintings in In Venice with Turner, London 1930.

Due to the sheer number of Turner's paintings and drawings, all sorts of publications focus on specific collections. These include M. Cormack, J,M.W. Turner, R.A., 1775–1851: A Catalogue of Drawings and Watercolours in the Fitzwilliam Museum, Cambridge, Cambridge 1975, and J. Dick, The Vaughan Bequest of Turner Watercolours, Edinburgh 1980.

From among the many **monographs**, Walter Thornbury's The Life of J.M.W. Turner, R.A., published in two volumes, London 1862 (revised edition: 1876) is entertaining to read as it includes numerous contemporary accounts. It is, however, not to be relied upon for factual accuracy. More up-to-date works include: A.J. Finberg, The Life of J.M.W. Turner, R.A., London 1939, revised in 1961, which is a scholarly publication including carefully researched details. Other books to be recommended are Jack Lindsay, Turner: A Critical Biography, London 1966 and

A. Wilton, The Life and Work of J.M.W. Turner, London 1979, which
includes a catalogue of paintings and watercolours. Turner in his Times,
London 1987, is by the same author.

Books providing a useful **overview with a biographical narrative**
include: Graham Reynolds, Turner, London 1969, reprinted 1976. This
volume is a fully documented critical study and covers as wide a range
of Turner's work as possible. Equally readable but focussing largely on
the artists travels is Inge Herold's Turner on Tour, Munich, London,
New York 1997 (reprinted 2004) which places the artist in an historical
framework.

General publications which assess Turner's life and the times in
which he lived include The Great Age of British Watercolours, 1750–1880,
Munich 1993. Edited by Andrew Wilton and Anne Lyles, this book
looks at the history of British watercolour painting and includes useful
biographical information on the major artists. G.D. Leslie's The Inner
Life of the Royal Academy, London 1914 and L. Hermann's Ruskin and
Turner, Oxford 1968 throw light on two very different but equally fasci-
nating influences in the artist's life.

Exhibitions focussing on every conceivable aspect of Turner's work
have been held around the globe, accompanied by **catalogues** of vary-
ing accuracy and standards. Catalogues of the exhibitions held in the
Clore Gallery at the Tate in London cover all the decades during which
Turner painted. Excellent reproductions can be found in Joseph
Mallord William Turner, edited by David B. Brown and Klaus Albrecht
Schröder, Munich, New York 1997, as well as essays on The Fallacies of
Hope and 'Storm, Steam and Light'.

J.M.W. Turner:
Portraits of the artist

There are very few self-portraits of Turner. While a few sketches exist
of the young Turner, only a handful of drawings or pictures depict the
artist as a mature man.

The most famous painting is his self-portrait entitled *Portrait of the
Artist aged about twenty-three*, executed in 1798/99 (see p. 5). It shows
a fashionably dressed, confident young man looking out of the canvas

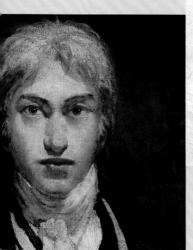

directly at the viewer. This is a Romantic self-image, bathed in a direct
light but surrounded by shadows and devoid of any background. He
presents himself as the classic hero, with his white neckerchief and
silver waistcoat.

In this self-portrait he shows himself face on and, therefore, hides his
large, bulbous nose from view – a feature often portrayed in later
caricatures of the artist. Even in early drawings of the young William
his nose became a dominant feature.

Self-portraits almost inevitably include symbols of the trade, social or professional attributes. It is unusual that Turner should depict himself without a brush in his hand or an easel in the background. Rembrandt was one of the few artists to have portrayed himself "as just a face and a mind." The comparison can be no coincidence. One art critic takes this notion much further saying: "By painting himself in this way, Turner asserts that art takes place in the head. His art is one not of appearance but of imagination. He does not show you something, but provokes you to imagine it. This portrait is a manifesto for the way his works try to awaken the inner eye."

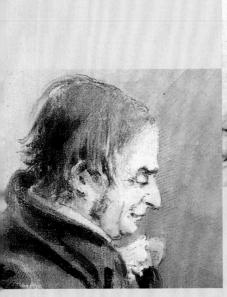

Turner was conscious of his appearance and commented some time later in his career that he did not like to be portrayed saying: "Those who view my countenance would not think it possible that I could paint pictures of such beauty." He was often ridiculed due to his lack of social graces and his somewhat unprepossessing appearance. Close friends, however, testified to Turner's warm-heartedness, good humour and generosity.

Barbizon School A group of French landscape painters who settled in Barbizon, a village on the outskirts of the Forest of Fontainebleau, south of Paris. Active between c. 1835–70, the most important members included Théodore Rousseau, Corot and Millet. Their naturalistic style marked the transition between Romanticism and Impressionism.

Complementary colours A primary colour (blue, yellow and red) which, when juxtaposed with the secondary colour produced by the other two primaries, makes it seem brighter or more intense; e.g. red strengthens green, blue strengthens orange and yellow strengthens violet.

Etching The process of making a design on a metal plate (usually copper). The plate is covered with an acid-resistant coating and the design drawn using a needle to expose the plate beneath. The plate is then immersed in an acid bath where the acid eats into the exposed metal. The longer the acid is allowed to be in contact with the metal, the deeper the lines become. The process can be repeated, each time 'stopping out' those parts that should remain unaltered with an acid-resistant material. The plate is then cleaned and inked for printing. An etching is always the mirror-image of the original design. The first dated etching is from 1513, but the heyday of this medium was in the seventeenth century.

Fresco A durable method of wall-painting using watercolours on wet lime or plaster. The pigments are suspended in water and unite with the plaster as they dry.

Genre painting Art that depicts scenes from daily life, especially of the kind popular in Holland in the seventeenth century.

Gouache An opaque water-colour paint (or poster paint) containing a gum binder with a filler of some form of opaque white (such as clay). This lends the material its typically chalky look. As it is easier to handle than oils, it is often used for studies for large oil paintings, although it dries lighter than when applied.

Mezzotint A method of engraving in which the artist works from dark to light. The ground is first covered with a regular fine scratching which takes the ink and appears as a black background. The design is burnished onto it, does not take the ink and therefore appears in white.

Nazarenes A group of early nineteenth-century German artists living in Rome established after 1810. They worked towards regenerating German painting by imitating Dürer, Perugino and Raphael.

Perspective The method of depicting a three-dimensional object on a flat plane. Claude Lorrain and other landscape artists often employed a method called *atmospheric perspective*, as a means of representing distance and recession in a painting, based on the way the atmosphere effects the human eye. Outlines become less distinct, small details are lost altogether, the colours become increasingly bluish and the overall colouring paler.

Tempera An emulsion used as a medium for a pigment, traditionally (but not exclusively) made with eggs. It dries extremely quickly and was widely used by Italian painters in the fourteenth and fifteenth centuries for fresco painting.

1,2/09